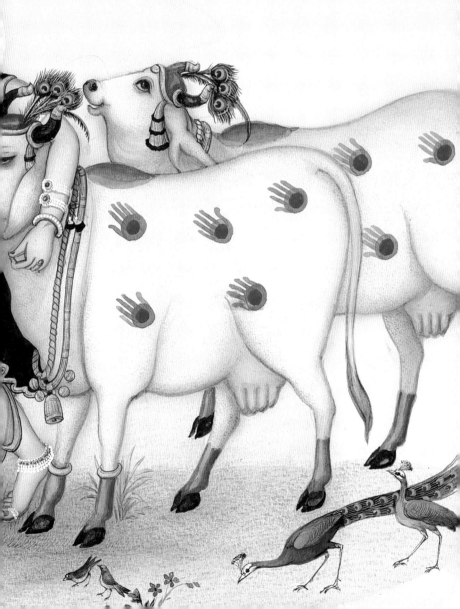

PROPERTY OF:

KRISHNA

B.G. SHARMA SIGNATURE EDITION

The stunning art of B.G. Sharma provides a glimpse into the magical life of Krishna, whose name denotes a blissful existence and who is the form of beauty that draws all near and leaves the unhappiness of material attachment behind. He includes all forms of the godhead and from him countless manifestations of divinity descend. And yet despite these myriad expressions, for Krishna, being in a universally creative mode means addressing life in a personal and intimate way—a philosophy at the heart of Sharma's work.

While revered throughout India for his originality in composition, design, and ornamentation, B.G. Sharma was also accomplished in the traditional schools of Kangra, Kishangarh, and Mughal painting. True to tradition, Sharma used a brush made from the tail of a squirrel for his miniatures and one made from a horse's tail for his larger paintings. The resultant art represents the divine play (*lila*) of Krishna and is a showcase of Sharma's spiritual journey and lifelong dedication to the form of beauty.

"This is my religion, and I express my devotion through my work."

B.G. Sharma

INSIGHTS

INSIGHT EDITIONS

San Rafael, California
www.insighteditions.com

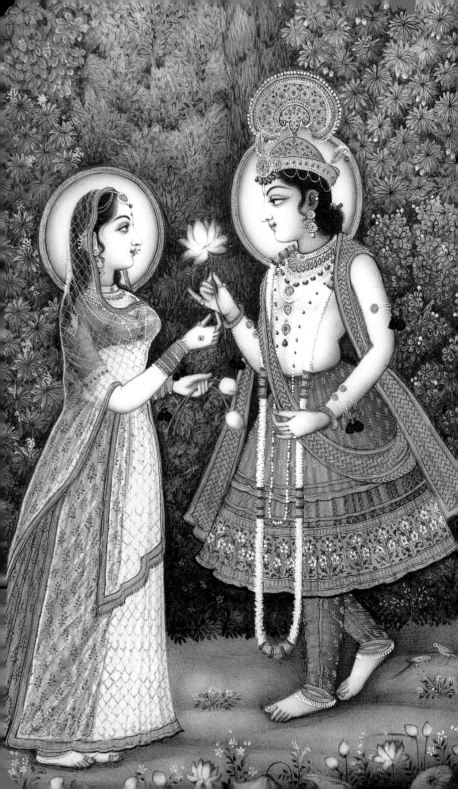